ART for GOD'S SAKE

Theologically rich and remarkably readable, this book offers sound biblical reasons to cultivate a sense of beauty."

— **Nancy Pearcey**, author of *Total Truth*

"This small book adddresses foundational issues that Christians face when they seek to intelligentlyand faithfully engage the visual arts."

— **Theodore L. Prescott**, Distinguised Professor of Art, Messiah College

ART *for*
GOD'S
SAKE

A CALL TO RECOVER THE ARTS

Philip Graham Ryken

P&R PUBLISHING
P.O. BOX 817 • PHILLIPSBURG • NEW JERSEY 08865-0817

Scripture quotations are from the HOLY BIBLE, NEW INTERNA- TIONAL VERSION®. NIV®. Copyright © 1973, 1978, 1984 by Inter- national Bible Society. Used by permission of Zondervan Publishing House. All rights reserved.

Italics within Scripture quotations indicate emphasis added.

Page design and typesetting by Dawn Premako

Printed in the United States of America

Library of Congress Cataloging-in-Publication Data
Ryken, Philip Graham, 1966–
 Art for God's sake : a call to recover the arts / Philip Graham Ryken.
 p. cm.
 Includes bibliographical references.
 ISBN-10: 1-59638-007-1
 ISBN-13: 978-1-59638-007-3
 1. Christianity and art. I. Title.

BR115.A8R97 2006
261.5'7—dc22

 2005053546

To Margaret, Jeff, and all their children;
to the sons and daughters of Jubal and Bezalel;
and to the beautiful Savior who puts the truth in their
work and the joy in their song.

INTRODUCTION

In the winter of 1996 I traveled to New York City to see paintings by Makoto Fujimura. The exhibition was called *Images of Grace*, and I was dazzled by what I saw. Fujimura has mastered the ancient Japanese art of *Nihonga*—in which mineral pigments are applied to paper—and wedded it to the Western style of abstract art. The results are magnificent. The use of mineral pigments gives Fujimura's work a shimmering depth of color, and as I moved through the gallery, I was stirred by the transcendent beauty of the paintings. His artwork also carries deep meaning, especially since each mineral pigment has a symbolic value. Gold represents eternal transcendence; silver—a precious metal that tarnishes through time—represents both the value and mutability of human life; and so on. Fujimura uses this traditional symbolism to give clear expression to his Christian faith. As the title *Images of Grace* suggests, the paintings in this particular exhibition

were about the grace of God: his common grace in creation, redeeming grace for the city, healing grace for downcast souls, and sacrificial grace for sinners.[1]

At its best, art is able to do what Fujimura's paintings do: satisfy our deep longing for beauty and communicate profound spiritual, intellectual, and emotional truth about the world that God has made for his glory. Is it any wonder that the best artists are celebrated?

But there is another side to art—a more difficult side. It is never easy to be a painter, a poet, a musician, or any other kind of artist. While every calling has its own unique trials and tribulations, the life of the artist seems especially hard. There is the difficulty of the art itself—of creating, executing, and perfecting a design or a composition. It is always costly, in personal terms, to produce a work of art. Then, once the work is produced, it is sometimes undervalued. People fail to hear its message or appreciate its artistry. To be an artist is often to be misunderstood. There is also the inescapable fact that many artists are underpaid. But even highly successful artists may struggle with feelings of isolation and inadequacy, with frustration over the elusiveness of expressing transcendent beauty, or with the heavy sadness of their sympathetic identification with human pain. These are some of the sufferings that artists must endure.

If anything, things are even more difficult for Christian artists. Some churches do not consider art a serious way to serve God. Others deny that Christians in the arts have a legitimate calling. As a result, Christian artists often feel like they have to justify their existence. Rather than providing a community of support, some churches surround them with a climate of suspicion.

These common tensions were exposed in an article from the student newspaper at a Christian college featuring a senior art student who reveled in her calling: "God made me to be an artist. He gave me that talent. . . . That's my response to God, to his world, to his message of salvation. When you see something that's so wonderful, you want to join." Unfortunately, as the artist learned, not everyone wants to join after all. "By the end of her sophomore year," the paper said, "she was sick of her peers' indifference to her calling. She was fed up with comments that suggested art is a waste of time, a field for slackers and weirdoes." The artist wrote in her journal, "I felt I had to justify myself. . . . That is a terrible thing. I am a child of God. God made me a person who sees the world in a manner that is different from most perceptions. He gave me the urge to create."[2]

What hope does the gospel give to someone who has this urge to create?

ART AND THE
CHURCH

There are many reasons why some churches have a negative view of the arts. Art trades in images, and images easily lend themselves to idolatry. Artists know this from their own experience. In their work they encounter the glory at the foundation of things, and they feel its power over the heart. But the danger is especially acute when objects of art are brought into the church for religious worship. At various times in church history, such as during the iconoclastic movement of the eighth century or the Protestant Reformation in Europe, church leaders have tried to smash this form of idolatry by taking statues and other works of art out of the church and destroying them. Generally speaking, they were not opposed to the use of art, only its abuse. But some Christians failed to understand the difference, and there was a lingering suspicion about the visual arts.

Other forms of art have come under suspicion for different reasons. Nearly all Christians acknowledge the worth of music in public worship, but some are skeptical of its value in other venues, where it is seen as unessential entertainment. The theater has long had an unsavory reputation for immorality; so too the cinema, with its dubious connections to Hollywood decadence. Then there is poetry, which is not so much opposed as ignored. Often the church's antipathy betrays an underlying ignorance about the arts, but sometimes the suspicion is justified. Art is always tempted to glory in itself, and nearly every form of art has been used to communicate values that are contrary to Scripture. Art is as fallen as any other aspect of human existence. This fallenness perverts the arts against fulfilling their original purpose and prevents us from embracing them uncritically.

More recently, many Christians have objected to art on the grounds that it is dominated by an anti-Christian view of the world. They rightly perceive that over the last century or more many artists, writers, and musicians have become increasingly cynical about the possibility of knowing the truth. In many cases, they have abandoned the quest to discover and express transcendent meaning. Art has also suffered a tragic loss of sacred beauty, as many modern and postmodern artists

have been attracted instead to absurdity, irrationality, and even cruelty. Stuart McAllister was right when he wrote that "much of the energy and effort of our artists and cultural architects has gone into debunking, dismantling, or deconstructing all that is good, beautiful, and respected, to be replaced with the shallow, the ugly, the ephemeral."[1] In many ways the art world has become—in the words of critic Suzi Gablik—a "suburb of hell." At times the pervasive sense of unhappiness is palpable. Anyone who doubts this should attend the senior exhibition at nearly any art school in America, or view the subversive artwork of recent winners of the Turner Prize,[2] or consider how much trouble major orchestras have capturing an audience for dissonant work written since 1950. There are exceptions, of course, but a good deal of contemporary art is the art of alienation, which, if it is true at all, is true only about the disorder of a world damaged by our depravity. God can use transgressive art to awaken the conscience and arouse a desire for a better world. But as a general rule, such artwork does not reveal the redemptive possibilities of a world that, although fallen, has been visited by God and is destined for his glory.

Yet even Christians who are dismissive of art continue to use it. Doing so is inescapable. Every time we

build a sanctuary, arrange furniture in a room, or pro-
duce a brochure, we are making artistic decisions. Even
if we are not artists in our primary vocation, there is an
inescapably artistic aspect to our daily experience. The
question becomes, therefore, whether as Christians we
will aspire to high aesthetic standards. All too often we
settle for something that is functional, but not beautiful.
We gravitate toward what is familiar, popular, or com-
mercial, with little regard for the enduring values of artis-
tic excellence. Sometimes what we produce can be
described only as *kitsch*—tacky artwork of poor quality
that appeals to low tastes. The average Christian book-
store is full of the stuff, as the real artists will tell us, if
only we will listen.

Ultimately this kind of art dishonors God because it
is not in keeping with the truth and beauty of his charac-
ter. It also undermines the church's gospel message of
salvation in Christ. Art has tremendous power to shape
culture and touch the human heart. Its artifacts embody
the ideas and desires of the coming generation. This
means that what is happening in the arts today is pro-
phetic of what will happen in our culture tomorrow. It
also means that when Christians abandon the artistic
community, we lose a significant opportunity to commu-
nicate Christ to our culture. Furthermore, when we set-

tle for trivial expressions of the truth in worship and art, we ourselves are diminished, as we suffer a loss of transcendence. What we need to recover (or possibly discover for the first time) is a full biblical understanding of the arts—not for art's sake, but for God's sake. Then we will be able to produce better art that more effectively testifies to the truth about God and his grace. This goal is important not just for artists, but also for everyone else made in God's image and in need of redemption.

THE ARTIST'S CALLING

*T*he dual purpose of this booklet is to encourage Christian artists in the pursuit of their calling and to give artists and nonartists alike a short introduction to thinking Christianly about the arts.[1] The proper basis for such thinking is the Bible, which affirms the value of art while at the same time protecting it from the corrupting effects of sin.

One good place to begin constructing a biblical view of art is Exodus 31, where God calls two men (Bezalel and Oholiab) to be artists. From the outset we need to recognize that although these men worked in the visual arts, their example has wider implications, with legitimate applications to other artistic media. At the same time, we need to realize that God gave these men a unique calling, and that therefore not everything in their experience is normative for all Christian art. Nevertheless, this passage teaches at least four funda-

mental principles for a Christian theology of the arts: (1)
the artist's call and gift come from God; (2) God loves all
kinds of art; (3) God maintains high standards for good-
ness, truth, and beauty; and (4) art is for the glory of God.
To complete our understanding of these principles, we
also need to see what they tell us about the character of
God and the artistry he displayed in the crucifixion and
resurrection of Jesus Christ.

Exodus 31 begins with God's calling two men to
be his official artists, and granting them the gifts they
needed to fulfill their vocation: "Then the LORD said to
Moses, 'See, I have chosen Bezalel son of Uri, the son of
Hur, of the tribe of Judah, and I have filled him with the
Spirit of God, with skill, ability and knowledge in all
kinds of crafts. . . . Moreover, I have appointed Oholiab
son of Ahisamach, of the tribe of Dan, to help him. Also
I have given skill to all the craftsmen to make everything
I have commanded you' " (Ex. 31:1–3, 6).

By this point in Exodus, God had given complete
instructions for constructing a giant tent and everything
that went inside it. This tabernacle, as it was called, was
designed to be an earthly copy of God's heavenly
dwelling place. In order to make it, an extraordinary
amount of work needed to be done: sawing, building,
sewing, cabinetmaking, casting, metalworking, stonecut-

ting, and engraving. Furthermore, God indicated that this work had to be done skillfully (e.g., Ex. 26:1; 28:3). So it was no job for Moses, even though he was the one writing down all the instructions. It wasn't his job because it wasn't his gift. Moses was a prophet, but the tabernacle needed an artist. In order to fulfill its divine function, God's holy dwelling had to be made by the best artisans, and with the finest materials.

So God called two men to serve as his holy artists—Bezalel and Oholiab, the master craftsman and his top assistant. These men were not selected by a jury of fellow artists, but appointed by the sovereign and electing choice of God. The Scripture literally says that they were called by name (Ex. 31:2, 6). Bezalel and Oholiab were God's personal choice for this job. And their calling as artists was so sacred that their names were preserved for posterity. "Bezalel" means "in the shadow of God." This is a good name for an artist working under divine direction and following a heavenly pattern, with God as the patron of his art.[2] The meaning of Oholiab's name was even more appropriate: "my tent is the Father-God."[3] Oholiab's job was to build God's dwelling on earth, and his name explained what that holy tent was designed to show, namely, that God is the shelter for his people.

Bezalel and Oholiab were not just called; they were also gifted. God gave Bezalel the "skill, ability and knowledge" to do all kinds of artwork (Ex. 31:3). Different scholars define these terms in different ways. According to John Durham, Bezalel is

> specially endowed for his assignment by an infilling of the divine spirit, which adds to his native ability three qualities that suit him ideally for the task at hand: wisdom, the gift to understand what is needed to fulfill Yahweh's instructions; discernment, the talent for solving the inevitable problems involved in the creation of so complex a series of objects and materials; and skill, the experienced hand needed to guide and accomplish the labor itself.[4]

Gene Edward Veith explains the vocabulary in this passage somewhat differently:

> "Skill" must refer to the artist's innate talent, described here as a gift of God. "Intelligence" underscores that a true artist not only works with his hands but with his mind, in contrast to current views that consider artistic inspiration to be nonrational or even anti-rational. "Knowledge" as a gift for the arts means that artists must know things, from the properties of their materials to the ideas that their art can convey. "Craftsmanship" refers to the artist's technique, the

difference between a work of any kind being poorly executed or well-made.[5]

Veith goes on to make the further point that these terms can be "used as criteria for evaluating any work of art, which may exemplify or fall short in some measure when it comes to skill, intelligence, knowledge, or craftsmanship."[6] But no matter how these terms are defined, they show that an artist needs spiritual insight as well as practical skill. Taken together, "skill, ability and knowledge" refer to what the artist is thinking in his mind and feeling in his heart, as well as to what he is making with his hands. The artistic work that Bezalel and Oholiab did came from their whole persons.

Like the materials these men used in their work, their artistic gifts all came from God. To be specific, they came from God the Holy Spirit. Presumably Bezalel and Oholiab already had some natural talent for the arts and crafts. But they were being given a special commission, and with that commission came special gifts. They alone were called to build God's holy tabernacle, and in order to do this work they were inspired in the true sense of the word: they were filled with the Holy Spirit. This is the first time that such language is used in the Bible, and it

teaches us something important about the arts. If he had wanted to do so, the Creator God could have built the tabernacle all by himself, without using Bezalel or Oholiab or anyone else to do it. Instead, God called artists to make the tabernacle, and to make sure that they did it well, he equipped them with every kind of artistic talent. By doing this, God was putting the blessing of his divine approval on both the arts and the artist.

The calling of these artists reflects a deep truth about the character of God, namely, that he himself is the supreme Artist. We know this because the very first thing God does in the Bible is to produce creative works of art: "In the beginning God created the heavens and the earth" (Gen. 1:1). And God does this creative work in an artistic and imaginative way. First he gathers his materials—in this case, miraculously, by making matter out of nothing. Next he gives structure and shape to what was previously "formless and empty" (Gen. 1:2). Over the course of six creation days, he orders the universe into its basic elements. Then, like a painter adding watercolors to a sketch, or like a composer developing variations on a melodic theme, God takes the forms of creation and adds content. He fills the water with sea creatures, the sky with birds, and the land with wild animals. Finally, he renders his artistic judgment on everything he has made, declar-

ing that it meets the standards of his divine aesthetic: "God saw all that he had made, and it was very good" (Gen. 1:31).

It is in this context that the Bible says, "God created man in his own image" (Gen. 1:27). But what does it mean, exactly, to say that people are made in God's image? Dorothy Sayers seeks to identify the precise point of connection when she asks:

> Is it his immortal soul, his rationality, his self-consciousness, his free will, or what, that gives him a claim to this rather startling distinction? A case may be argued for all these elements in the complex nature of man. But had the author of Genesis anything particular in mind when he wrote? It is observable that in the passage leading up to the statement about man, he has given no detailed information about God. Looking at man, he sees in him something essentially divine, but when we turn back to see what he says about the original upon which the "image" of God was modeled, we find only the single assertion, "God created." The characteristic common to God and man is apparently that: the desire and the ability to make things.[7]

Sayers has a solid biblical foundation for seeing creativity as one (although not the only) basic aspect of the

image of God in people. If the opening chapters of Genesis portray God as a creative artist, then it only stands to reason that the people he made in his image will also be artists. Art is an imaginative activity, and in the act of creating, we reflect the mind of our Maker. Like God himself, said Abraham Kuyper, we have "the possibility both to create something beautiful, and to delight in it."[8] This is true of all artists, and indeed of all people, but it has special significance for Christians. Because we know God as both our Creator and our Redeemer, we seek to display his beauty and grace in our life and work.

No one else will ever receive the unique calling or special gifting that Bezalel and Oholiab were given to build a house for God. Yet their example serves as a reminder that God will equip us to do whatever he calls us to do. Neither Bezalel nor Oholiab had ever built a tabernacle before. Nevertheless, God called them to build it, and when he called them, he also equipped them. The same is true for everyone who serves God, including artists. When God calls us to do something, we are to trust that he will also give us whatever we need to fulfill that calling.

The example of Bezalel and Oholiab also shows that God chooses some men and women to be artists.

Similarly, the Bible identifies Jubal as "the father of all who play the harp and flute" (Gen. 4:21), and records the wedding song of a royal poet whose "tongue is the pen of a skillful writer" (Ps. 45:1). The calling of these artists legitimizes the artistic vocation. What was true for them in a special way is true in a more general way for every artist. Artists are called and gifted—personally, by name—to write, paint, sing, play, and dance to the glory of God.

How does someone know whether he or she is called to some form of art as a full-time career? There must be a passion for this, of course, since God generally calls us to serve him in ways that resonate with the holy desires of our hearts. But passion alone is not sufficient. To survive and thrive in the arts as a profession, an artist must also be strongly gifted. It is worth noting that the artists called to assist Bezalel and Oholiab in building the tabernacle were those to whom God "had given ability" *and* who were "willing to come and do the work" (Ex. 36:2).

The most reliable way to discern one's gifts is to submit to the judgment of experts. As a matter of good stewardship, Christians who practice one or more of the fine arts should strive to make an accurate assessment of their artistic abilities and to develop their skill accordingly.

The gifts of someone who is truly gifted will be confirmed by those who are qualified to know.

This call should then be pursued, no matter what sacrifices are required. Most artists face difficult decisions about meeting their practical needs, especially while they are still training for careers in the arts. Often they have to supplement their income, sometimes by doing something not directly related to their artwork. This, too, can be part of God's plan. But one thing true artists should never do is to abandon their calling. Anyone who is called to be an artist should be an artist! God's gifts are never to be hidden; his calling is never to be denied. And like everything else that we do, our art is to be done "in the name of the Lord Jesus, giving thanks to God the Father through him" (Col. 3:17). The life of the artist—like the life of any other Christian—is a life of daily dependence on the grace of God, with constant prayer for his blessing.

In the providence of God, some people who hope to become artists never reach their desired goal. This may be for reasons of practical necessity, or because they never reach the level of excellence required to sustain a career in the arts. In such cases it is important not to focus on the frustration of not achieving one's ambitions, but to recognize that there are other meaningful ways to participate in the arts. A full understanding of the arts

recognizes both the unique vocation of the professional artist and the value of other forms of artistic expression. Even if our art must become an avocation rather than a vocation, it should still be pursued with deep joy and a strong sense of purpose. The church can help in this pursuit by serving as a community of encouragement that affirms the calling of artists and nurtures the artistic aspect of every human soul.

ALL KINDS OF ART

A second principle for a Christian theology of art is that God loves all kinds of art. "All kinds" does not mean that all works of art are good or godly. God has high standard for art, and obviously he does not and cannot endorse the content of work that is pornographic or propagandistic, or that violates his character in some other way. What is meant instead is that God blesses a rich variety of art forms. In Exodus 31 God gives Bezalel a wide range of artistic gifts and says, "I have filled him with the Spirit of God, with skill, ability and knowledge in *all kinds* of crafts—to make artistic designs for work in gold, silver and bronze, to cut and set stones, to work in wood, and to engage in all kinds of craftsmanship" (Ex. 31:3–5).

Bezalel was able to work in a wide variety of artistic media. He was a metalworker, stonecutter, and woodworker, with the talent to work at "all kinds of craftsmanship." Oholiab was equally versatile. Later we learn that in

addition to helping Bezalel with his other work, Oholiab served as "a craftsman and designer, and an embroiderer in blue, purple and scarlet yarn and fine linen" (Ex. 38:23). Most artists do their best work in a narrow specialty, but like Michelangelo or Mozart, these men had the rare ability to work with equal skill in various media.

In granting them this gift, God placed his seal of approval on the flourishing of the arts. Some artists have the gift of making things out of wood, others out of paper. There are different kinds of painting, with some artists working in oil, others working with watercolors. There are different kinds of drawings: sketches and line drawings in pencil, ink, and charcoal. There are many things that can be done with thread or yarn, from knitting to macramé. There are various techniques for making sculptures in wood, clay, stone, or metal. Then there are the performing arts, such as drama and dance. These, too, have God's blessing. So does music, which in the Bible is mentioned more frequently than any other kind of art. The forms of artistic expression are seemingly infinite. In Exodus 31 God sanctifies a wide spectrum of artistic gifts by blessing "all kinds of craftsmanship." Most arts and crafts—from filmmaking to decoupage—are not explicitly mentioned here or anywhere else in the Bible. What the

Bible does show, however, is that God blesses various kinds of art.

Bezalel and Oholiab needed to work in so many different media because the tabernacle had so many different parts. These men and their helpers were called to employ their varied skills to make many things. God said:

> I have given skill to all the craftsmen to make every-thing I have commanded you: the Tent of Meeting, the ark of the Testimony with the atonement cover on it, and all the other furnishings of the tent—the table and its articles, the pure gold lampstand and all its accessories, the altar of incense, the altar of burnt offering and all its utensils, the basin with its stand—and also the woven garments, both the sacred gar-ments for Aaron the priest and the garments for his sons when they serve as priests, and the anointing oil and fragrant incense for the Holy Place. They are to make them just as I commanded you. (Ex. 31:6b–11)

This list summarizes what went into the tabernacle. Israel's artists were called to make the tent itself, with all the *objets d'art* that went inside. God took whole chapters of Scripture to explain what to make, and how to make it. But it was up to Bezalel, Oholiab, and the rest of Israel's artistic community to execute God's design.

Some commentators think that all the artists had to do was to copy God's pattern. According to one scholar, "the works they were to produce had been described in detail already to Moses. No room is left for creative variations on the plans Yahweh had given."[1] It is true that God gave Moses plenty of instructions, yet he left many things unspecified (which is why we don't know exactly what the tabernacle looked like). God did not explain how the cherubim were supposed to appear. He didn't describe the decorative molding that went around the rim of the table of showbread. He didn't provide a pattern for weaving the colorful threads in the high priest's robe or tell Moses what script to use for the inscription on his turban. These things were left up to the artists' sanctified imaginations.

This is what usually happens when an artist receives a commission. Whoever commissions the work has some idea what the finished product will look like. Yet the artist has the freedom to create the work of art itself. For example, the architects who submit plans for a public building have to meet certain requirements in terms of location and square footage. But they are free to decide what the buildings will look like. God's plans for the tabernacle were much more specific. This is because the tabernacle was for God, who has the right to tell us how he wants to

be worshiped. But even in the tabernacle, many things were left up to the artists, who were free to use their imaginations within the bounds of obedience to God.

We should notice that Bezalel and Oholiab produced three major kinds of visual art: symbolic, representational, and nonrepresentational (or abstract) art.[2] Symbolic art (which can be either representational or nonrepresentational) uses a physical form to stand for a spiritual reality. So, for example, the ark of the covenant symbolized atonement and the golden lampstand symbolized the light of God's glory and grace. Representational art imitates life by portraying a recognizable object from the physical universe. A good example from the tabernacle is the use of pomegranates on the robe of the high priest. Nonrepresentational or abstract art is pure form, such as the colorful curtains in the Holy Place, or the shape of the physical spaces that made up the tabernacle complex. As the house of God on earth, the tabernacle was a supreme statement of eternal values. Its design and ornamentation thus serve as a divine endorsement of symbolic, representational, and nonrepresentational art.

We find similar variety in what the Bible says about music. When the psalmist says, "Sing to him a new song; play skillfully, and shout for joy" (Ps. 33:3),

he is issuing a summons to vocalists ("sing to him"),
composers ("a new song"), instrumentalists ("play skill-
fully"), and audiences ("shout for joy"). As far as instru-
mentation is concerned, passages throughout the
Psalms refer to all four main forms of music: strings,
woodwinds, brass, and percussion. The ascriptions to
the Psalms also contain evocative references to musical
tunes, such as "The Death of the Son" (Ps. 9) and "The
Lily of the Covenant" (Ps. 60). The Bible is full of
many kinds of music. And as for literature, what further
endorsement is needed beyond the Bible itself, which
is the world's richest anthology of stories, poems, his-
torical narratives, romances, soliloquies, psalms,
laments, prophecies, proverbs, parables, epistles, and
apocalyptic visions?

Some Christians continue to think that certain
forms of art are more godly than others. They make a
sharp distinction between the sacred and the secular,
not recognizing that so-called secular art is an explo-
ration of the world that God has made, and therefore
has its place in deepening our understanding of God's
person and work. Christians usually prize symbolic art,
especially if its symbolism is religious. Repre-
sentational art is also valued because it imitates the
world that God has made.

What Christians tend to dismiss is abstract art, especially as it has come to expression in modern art. Yet abstraction has God's blessing as much as any other art form. The example of the tabernacle proves that God loves all kinds of art, in all kinds of media and all kinds of styles—provided, that is, that they are in keeping with the perfections of his character. As John Calvin said, "All the arts come from God and are to be respected as divine inventions."[3] Therefore, as Christians we are not limited to crosses and flannel-graphs, or to praise choruses and evangelistic skits. These simple forms may have their place in the life of the church, but God wants all of the arts to flourish in all the fullness of their artistic potential, so that we may discover the inherent possibilities of creation and thereby come to a deeper knowledge of our Creator.

THE GOOD, THE
TRUE, AND THE
BEAUTIFUL

*T*he latitude God gives to the arts, however, does not mean that anything goes. God has high standards for art, as he does for everything else. Using Exodus 31 as a guide—and this is our third principle for thinking Christianly about the arts—God's aesthetic standards include goodness, truth, and beauty. And these standards are not relative; they are absolute. A Christian view of art thus stands in opposition to the postmodern assumption that there are no absolutes.

Goodness is both an ethical and an aesthetic standard. Obviously, Bezalel and Oholiab were not allowed to make anything that violated the Ten Commandments—especially the second commandment, which outlawed idolatrous images of the divine being, or any other form of

false worship (see Ex. 20:4–5). Similarly, Christian artists are not allowed to make anything that is immoral or that is designed to serve as an object of religious worship. But goodness is also an aesthetic category. Israel's artists were called to make good art—art that was excellent, art that demonstrated thorough mastery of technique in a particular artistic discipline. At the end of his instructions, God said that Bezalel and Oholiab were to make everything according to his specifications (Ex. 31:11), and if we scan the preceding chapters, we see just how specific God can be. God's careful instructions for building the tabernacle remind us that his perfection sets the standard for whatever we create in his name. Whatever we happen to make—not only in the visual arts, but in all the arts—we should make it as well as we can, offering God our very best.

This is not to say that the Bible provides any specific information about the skills required for any particular form of art. Rather, the standards for artistic goodness come from creation itself. They are intrinsic to the physical materials—to the sights and the sounds—of any artistic craft. "What can an artist use but materials, such as they are?" wrote Annie Dillard. "What can he light but the short string of his gut, and when that's burnt out, any muck ready to hand?"[1] So the photographer learns the properties of light and shadow, as well as the technical

aspects of taking and developing photographs. Or the vocalist learns to sing by experimenting with resonance, articulation, and other factors in the production of sound, and then by listening to the results. What constitutes excellence in these and other art forms is inherent in the art forms themselves, and thus it comes from God as part of his general revelation. The difference between good art and bad art is not something we learn from the Bible, primarily, but from the world that God has made. But what the Bible *does* tell us is that God knows the difference, and that he has a taste for excellence.

To be pleasing to God, art must be true as well as good. Truth has always been one important criterion for art. Art is an incarnation of the truth. It penetrates the surface of things to portray them as they really are. The tabernacle is a good example. The whole building was designed to communicate truth about God and his relationship with his people. And in order to fulfill this purpose, the artistry that went into the tabernacle had to be true. It had to be true to nature. When it represented something in creation—flowers, for example, or pomegranates—it had to be true to what God had made. It also had to be true to who God is. Each part of the tabernacle said something about God. The golden ark symbolized the authority of his royal throne; the bronze basin signi-

fied his power to wash away sin; and so forth. In order to accurately communicate these truths, the tabernacle had to tell the truth. Its art was in the service of its truth.

Art communicates truth in various ways. Sometimes it tells a story, and the story is true to human experience—it is an incarnation of the human condition. Sometimes art tells the truth in the form of propositions. This is especially characteristic of literary art forms, which speak with words. Art can also convey emotional and experiential truth, and it can do this without words, as is often the case with music. But whatever stories it tells, and whatever ideas or emotions it communicates, art is true only if it points in some way to the one true story of salvation—the story of God's creation, human sin, and the triumph of grace through Christ.

Modern and postmodern art often claim to tell the truth about the pain and absurdity of human existence, but that is only part of the story. The Christian approach to the human condition is more complete, and for that reason more hopeful (and ultimately more truthful). Christian artists celebrate the essential goodness of the world that God has made, being true to what is there. Such celebration is not a form of naive idealism, but of healthy realism. At the same time, Christian artists also lament the ugly intrusion of evil into a world that is

warped by sin, mourning the lost beauties of a fallen paradise. When truly Christian art portrays the sufferings of fallen humanity, it always does so with a tragic sensibility, as in the paintings of Rembrandt. There is a sense not only of what we are, but also of what we were: creatures made to be like God.

Even better, there is a sense of what we can become. Christian art is redemptive, and this is its highest purpose. Art is always an interpretation of reality, and the Christian should interpret reality in its total aspect, including the hope that has come into the world through the life, death, and resurrection of Jesus Christ. Rather than giving in to meaninglessness and despair, Christian artists know that there is a way out. Thus they create images of grace, awakening a desire for the new heavens and the new earth by anticipating the possibilities of redemption in Christ. And according to the Dutch critic Hans Rookmaaker, it is the Christian teaching about grace that resolves

> the very practical problem of how we are to live in a world that is full of sin and ungodliness. Where things are loving, good, right and true, where things are according to God's law and His will for creation, there is no problem. The Christian will appreciate and actively enjoy and enter into all the good things God

has made. But where they have been spoilt or warped by sin, then the Christian must show by his life, his words, his action, his creativity what God really intended them to be. He has been made new in Christ, been given a new quality of life which is in harmony with God's original intention for man. He has been given the power of God Himself by the Holy Spirit, who will help him to work out his new life into the world around him.[2]

The kind of art that glorifies God is good, true, and, finally, beautiful. Today it sometimes seems as though the art world is struggling to overcome an aesthetic of ugliness. Beauty used to be one of the artist's highest priorities; now for many artists it is among the lowest priorities, if it is even a criterion for artwork at all. But God is a great lover of beauty, as we can see from the collection of his work that hangs in the gallery of the universe. Form is as important to him as function. Thus it was not enough for the tabernacle to be laid out in the right way; it also had to be beautiful. There was beauty in the color of its fabrics, the sparkle of its gems, the shape of its objects, and the symmetry of its proportions. The tabernacle was a thing of beauty. God made sure of this by taking the unprecedented step of endowing its artists with the gift of his Spirit. All

of this tells us something about what kind of artist God is: an artist who loves beauty.

Beauty and truth belong together. As the poet John Keats said in his famous "Ode on a Grecian Urn," "beauty is truth, truth beauty—that is all ye need to know." Taken literally, Keats's identification of truth and beauty (to say nothing of his claim that this is the sum of all knowledge) is an exaggeration; yet truth and beauty *are* interconnected. The problem with some modern and postmodern art is that it seeks to offer truth at the expense of beauty. It tells the truth only about ugliness and alienation, leaving out the beauty of creation and redemption. A good deal of so-called Christian art tends to have the opposite problem. It tries to show beauty without admitting the truth about sin, and to that extent it is false— dishonest about the tragic implications of our depravity. Think of all the bright, sentimental landscapes that portray an ideal world unaffected by the Fall, or the light, cheery melodies that characterize the Christian life as one of undiminished happiness. Such a world may be nice to imagine, but it is not the world God sent his Son to save.

So what kind of art is able to meet God's standards, as exemplified in the tabernacle? Not art that is bad, false, or ugly, but art that incarnates the good,

the true, and the beautiful. In other words, our art must be in keeping with the character of our God, who himself is good, true, and beautiful. The Scripture says that God is good and does good (e.g., Pss. 107:1; 119:68), that he is truthful and true (e.g., Isa. 45:19; 1 Thess. 1:9), and that he is beauteous in his being (Ps. 27:4). And now this good, true, and beautiful God says to us, in words that might well serve as a manifesto for Christianity and the arts: "Whatever is true, whatever is noble, whatever is right, whatever is pure, whatever is lovely, whatever is admirable—if anything is excellent or praiseworthy—think about such things" (Phil. 4:8). Although this verse has wider implications for the whole Christian life, at the very least it outlines a set of ethical and aesthetic norms for the artist and for art.

This does not mean that goodness, truth, and beauty are always easy to define (especially beauty). Nor does it mean that Christian artists never portray anything ugly. We have truth to tell about the ugliness of a fallen world. Indeed, Christianity offers the best explanation for that ugliness in its doctrine of depravity: the world has been spoiled by sin. Francis Schaeffer helpfully identified this as "the minor theme" of Christian art, namely, the lostness of

humanity outside of Christ and the "defeated and sinful side to the Christian's life." But we are always drawn to the beauty that endures—the truth of what we were, what we are, and what we can become in Christ. According to Schaeffer, this is "the major theme" of the Christian worldview: the grace of God that gives meaning and purpose to life.[3] In a world that has been uglified by sin, the Christian artist shows the plausibility of redemption by producing good work that is true in its beauty.

ART FOR THE
GLORY OF GOD

fourth principle for a Christian theology of the arts is that art is for God's sake. Artists sometimes talk about art for art's sake. What they mean is that art has intrinsic worth: it has value in and of itself, apart from any utility. This needs to be said because there are always some people who wonder why we need art, on the assumption that in order to be a legitimate calling it must perform some practical function. But since God has made us to enjoy beauty, art itself is able to nourish our souls. Ralph Waldo Emerson wrote, "Beauty is its own excuse for being."[1] Emerson was going too far, of course, because even beauty serves the glory of God, but the artistry of the tabernacle at least proves that beauty has its own intrinsic value. Some of its features—such as the gold molding on the ark of the covenant—were purely decorative. When Bible scholars try to find a spiritual meaning for every detail, they are

missing the point. Some of the artistry in the tabernacle was art for art's sake, in the full and proper sense of that expression.

The problem is that artistry easily becomes idolatry, and when this happens, art is seen to exist only for its own sake and not for any higher purpose. Or perhaps it exists for some higher purpose within creation that nevertheless falls short of the glory of God (see Rom. 1:25). The giving and receiving of art is as fallen as any other human enterprise. When we experience art, therefore, we must always ask the question: Whom does this glorify? Rather than dedicating their work to God, some artists produce it for their own glory. Unwittingly, their work may still bear their Maker's praise, but they have failed to achieve the highest purpose of their life and art. It is said that when Henri Matisse completed his masterly paintings in the Chapel of the Rosary at Venice, he stepped back and proclaimed, "I did it for myself." One of the Catholic sisters overheard him and immediately objected: "But you told me you were doing it for God." "Yes," Matisse replied, "but I am God."[2]

Matisse is hardly the only artist ever to have had delusions of deity. Even Christian artists may succumb to pride for the recognition of their work. There is a reason

for this: it is the best things in life that threaten to steal our worship, and art is such a wonderful gift that those who love it sometimes forget to praise its Giver. Anyone who doubts the tendency of artistry to become idolatry needs only to read on into Exodus 32, where, while Moses was up on the mountain to receive God's commission for the tabernacle, Aaron was busy fashioning a golden calf for the Israelites to worship as their god. The whole sordid episode shows what happens when people pursue art for their own purposes: they end up worshiping art rather than God.

How can artists avoid making this mistake? By acknowledging their artistic ability as a gift from God. The composer Igor Stravinsky wisely said, "I take no pride in my artistic talents; they are God-given and I see absolutely no reason to become puffed up over something that one has received."[3] Artists also avoid idolizing the arts by resisting any temptation to isolation and instead living in the Christian community, where worship is given to God alone, where a God-centered orientation to life is the basis for daily discipleship, and where every earthly calling finds its true significance in relation to the higher calling of God. Artists also avoid idolatry by offering their art in praise to God. It is when we create things for God's sake that our work most

clearly promotes his glory, rather than threatening to compete with it. Thus the true purpose of art is the same as the true purpose of anything: it is not for ourselves or for our own self-expression, but for the service of others and the glory of God. Or to put all of this another way, making art is an expression of our love—love for God and love for our neighbor.

Art for God's sake—this is what the tabernacle was all about. Every detail in that sacred building was for the praise of God's glory. The altar and the atonement cover (also known as the mercy seat) testified to his grace. The table of the showbread proclaimed his providence. The lampstand spread his light. But even the things that were not symbolic were for God. This is why the tabernacle was made so carefully, with such fine materials and elaborate decorations: it was all for the glory of God.

The same should be true of everything that we create: it should all be for God's glory. In one sense, this is inherently true of all good art, whether or not it happens to be produced by people who actually intend to glorify God. The doctrine of creation teaches that by God's common grace, the gift of art inevitably declares the praise of its Giver. Thus non-Christian as well as Christian artists can represent virtue, beauty, and truth. It is important to remember, as Nigel Goodwin has said,

that "God in His wisdom did not give all His gifts to Christians."[4] But even if God may be glorified by art that is not explicitly offered in his honor, he is most truly praised when his glory is the aim of our art.

This does *not* mean that all our art has to be evangelistic in the sense that it explicitly invites people to believe in Christ. To give an example from another calling, the way in which a Christian who makes cars glorifies God is not by painting "John 3:16" on the hood. Rather, he glorifies God by making a good car. Similarly, the artist glorifies God by making good art, whether or not it contains an explicit gospel message. The sculptor glorifies God in her sculpture; the architect glorifies God in his building; and so forth. Because it works with the materials of creation, the artistry itself is capable of conveying the artist's commitment to a good, loving, and gracious Creator.

Another way to say this is that art can be Christian without serving merely as a vehicle for evangelism, or for other forms of preaching. Such a utilitarian perspective impoverishes the arts. A more complete perspective on Christian art recognizes that a creation always reveals something about its creator. What artists make tells us something about how they view the world. Thus the art of a Christian ought to be consistent with a life of faith in Christ. This is not always the case, of course, because

artists struggle with their fallen nature as much as anyone else. Nevertheless, as Francis Schaeffer wrote, "Christian art is the expression of the whole life of the whole person who is a Christian. What a Christian portrays in his art is the totality of life."[5] Johann Sebastian Bach is famous for signing his works with the letters "sDg," standing for the Latin phrase *soli Deo gloria* — "to God alone be the glory." This was a pious act that indicated the composer's sincere desire to present his art as an offering to God. The important thing, however, was not so much the letters that Bach added to his score, but the music itself, which in its ordered beauty was a testimony to his faith in God. In the same way, every artist whose talents are under the lordship of Jesus Christ will produce art for God's sake.

BEAUTIFUL SAVIOR

*T*o summarize, this is the Christian view of art: the artist is called and gifted by God—who loves all kinds of art; who maintains high aesthetic standards for goodness, truth, and beauty; and whose glory is art's highest goal. We accept these principles because they are biblical, and also because they are true to God's character. What we believe about art is based on what we believe about God. Art is what it is because God is who he is.

Along the way, we have seen that each of our principles reveals something about God's own divine being and attributes. Why does God call people to be artists? Because he is an Artist, and we are made in his image. When we first meet the God of the Bible, he is busy making things and calling them good. Thus it is only natural for him to take some of the people that he has made, call them to be artists, and hold them to an aesthetic standard.

Why does God love all kinds of art? Because he is infinite in his perfections and has made a universe that is vast in its variegated beauty—everything from galaxies in motion to warblers on the wing. To serve such a God, in such a world, the arts must flourish in all their variety. And they should be measured against objective standards of goodness, truth, and beauty. These are God's standards because they are essential attributes of his being. He is a good, true, and beautiful God, as we see in the radiance of his eternal Son. The great American theologian Jonathan Edwards said, "All the beauty to be found throughout the whole creation, is but the reflection of the diffused beams of that Being who hath an infinite fullness of brightness and glory; God . . . is the foundation and fountain of all being and all beauty."[1] And since God is so infinitely beautiful, all our art is rightly dedicated to his glory. What comes from him should return to his praise.

If God has such a passion for the arts, then we should expect him to reveal his artistry in the plan of salvation. But here we come up against a shocking reality, namely, that the center of God's masterpiece of salvation was an event of appalling ugliness and degradation. This masterpiece was the cross where Christ was crucified for sin, and there was nothing beautiful about it, at least not in physical terms. The crucifixion was an ugly, ugly

obscenity—a twisting, bleeding body of pain. As Isaiah wrote, concerning the crucified Christ:

> He had no beauty or majesty to attract us to
> him,
> nothing in his appearance that we should
> desire him.
> He was despised and rejected by men,
> a man of sorrows, and familiar with suffering.
> Like one from whom men hide their faces
> he was despised, and we esteemed him not.
> Surely he took up our infirmities
> and carried our sorrows,
> yet we considered him stricken by God,
> smitten by him, and afflicted. (Isa. 53:2b–4)

God sent his Son to be our Savior: that was the plan. But what God sent him to do was grotesque. How can we explain this? Why would the God of all glory and beauty do something so ugly, and then make us look to it for our salvation? The cross screams against all the sensibilities of his divine aesthetic.

God did this because it was the only way that he could save us. Sin had brought ugliness and death into the world. In order to save his lost creation, God sent his Son right into all the absurdity and alienation. There

Jesus took our sin upon himself, dying to pay the price that justice demanded. It was such an ugly death that people had to turn away. Not even God himself could bear to see the sin that Jesus carried, as we know from the darkness that descended over the cross (Matt. 27:45) and from Jesus' cry of dereliction: "My God, my God, why have you forsaken me?" (Matt. 27:46).

This is not how the story ends, however. God did not simply leave his Son in death and decay. No, he's much too good an artist for that. His design was to transform ugliness into beauty. He did this first with the body of his Son, raising Jesus from the dead and giving him a glorious resurrection body more beautiful than anything we can imagine. That body still bears the marks of the crucifixion. We know this because Jesus invited his disciples to touch the places where he had been pierced (see John 20:27). But those ugly wounds have been transformed into glory. The hymn-writer Matthew Bridges described it well: "behold his hands and side, rich wounds, yet visible above, in beauty glorified." For all eternity the body of Jesus will bear reminders of the suffering he endured for sin—now transformed into glorious beauty, and worshiped with an everlasting symphony of praise.

God will do the same thing with everyone who has faith in Jesus Christ. Whenever we are tempted to be dis-

couraged by the ugliness of our sin, we need to remember that we are still a work in progress. The Scripture says that "we are God's workmanship [or "craftsmanship"— the Greek term *poema* was often used in connection with the arts], created in Christ Jesus to do good works, which God prepared in advance for us to do" (Eph. 2:10). Our salvation is directed by a redemptive aesthetic. By his grace, one day the best of artists will take everything that has been disfigured by our depravity and transform us into people of beauty who will be a joy forever.

What kind of art would be worthy of such a God? Only good art: art that works within the potentialities of creation to reflect the goodness of God's being. Only true art: art that tells the truth about sin and is sensitive to the tragedy of suffering in a fallen world. Only beautiful art: art that incarnates the hope of our redemption and refuses to allow despair to serve as the ultimate perspective on human existence. And only glorious art: art that anticipates the coming of God's glory in the person of Jesus Christ.

In his wonderful little book *Art and the Bible*, Francis Schaeffer describes a mural in the art museum at Neuchatel, painted by the Swiss artist Paul Robert. Schaeffer writes:

> In the background of this mural he pictured Neuchatel, the lake on which it is situated and even

the art museum which contains the mural. In the foreground near the bottom is a great dragon wounded to the death. Underneath the dragon is the vile and the ugly—the pornographic and the rebellious. Near the top Jesus is seen coming in the sky with his endless hosts. On the left side is a beautiful stairway, and on the stairway are young and beautiful men and women carrying the symbols of the various forms of art—architecture, music and so forth. And as they are carrying them up and away from the dragon to present them to Christ, Christ is coming down to accept them.[2]

What Robert's mural represents is the triumph of beauty and the redemption of the arts. Schaeffer comments that the hope of this future reality should shape the present, for "if these things are to be carried up to the praise of God and the Lordship of Christ at the Second Coming, then we should be offering them to God now."[3] Indeed we should. As Christians, we should lead the way in reclaiming the arts and restoring them to their true purpose. We are living in a fallen and broken world; yet for all its ugliness, this world was made by God and will be saved by his grace. Therefore, we should devote our skill to making art for the glory of God, and for the sake of his Son—our beautiful Savior, Jesus Christ.

FOR FURTHER
READING

Bustard, Ned, ed. *It Was Good—Making Art to the Glory of God*. Baltimore: Square Halo Books, 2000.

Carson, D. A., and John D. Woodbridge, eds. *God and Culture: Essays in Honor of Carl F. H. Henry*. Grand Rapids: Eerdmans, 1993.

Edgar, William. *Taking Note of Music*. London: SPCK, 1986.

Gaebelein, Frank E. *The Christian, the Arts, and Truth: Regaining the Vision of Greatness*. Edited by D. Bruce Lockerbie. A Critical Concern Book. Portland, OR: Multnomah, 1985.

Kuyper, Abraham. *Calvinism: Six Stone Foundation Lectures*. Grand Rapids: Eerdmans, 1943.

Lewis, C. S. *An Experiment in Criticism*. Cambridge: Cambridge University Press, 1956.

Rookmaaker, Hans R. *Modern Art and the Death of a Culture*. Downers Grove, IL: InterVarsity, 1970.

Ryken, Leland. *The Liberated Imagination: Thinking Christianly about the Arts*. The Wheaton Literary Series. Wheaton, IL: Harold Shaw, 1989.

Ryken, Leland, ed. *The Christian Imagination: Essays on Literature and the Arts.* Grand Rapids: Baker, 1981.

Sayers, Dorothy L. *The Mind of the Maker.* Cleveland: World, 1956.

Schaeffer, Francis A. *Art and the Bible.* Downers Grove, IL: InterVarsity, 1973.

Seerveld, Calvin. *Rainbows for the Fallen World: Aesthetic Life and Artistic Task.* Toronto, ON: Toronto Tuppence Press, 1980.

Veith, Gene Edward. *State of the Arts: From Bezalel to Mapplethorpe.* Turning Point Christian Worldview Series. Wheaton, IL: Crossway, 1991.

NOTES

Introduction

1 See Makoto Fujimura, *Images of Grace* (New York: Dillon Gallery Press, 1997). For more information about Fujimura and his work with the International Arts Movement, go to www.iamny.org.

2 Emily Cottrill, quoted by Lucas McFadden in "Freedom of Expression? The Plight of Wheaton Artists," *The Record* (September 27, 2002): 6–7.

Art and the Church

1 Stuart McAllister, "What Is Good and Who Says?" as quoted by Ned Bustard, "God Is Good Like No Other," in *It Was Good—Making Art to the Glory of God* (Baltimore: Square Halo Books, 2000), 13–14.

2 Witness the vulgar creations of Martin Creed, Tracey Emin, Grayson Perry, and others; see Gene Edward Veith, "Stealing Beauty," *World* (March 20, 2004): 32–41.

The Artist's Calling

1 While accepting full responsibility for all the inadequacies that remain, the writer wishes to thank Craig and

Margaret Claudin, Bill Edgar, Mako Fujimura, Sam Hsu, Paul Jones, Sheryl Woods Olson, and Leland Ryken for making substantial improvements to this essay.

2 This insight comes from Frank E. Gaebelein, *The Christian, the Arts, and Truth: Regaining the Vision of Greatness*, ed. D. Bruce Lockerbie, A Critical Concern Book (Portland, OR: Multnomah, 1985), 64.

3 R. Alan Cole, *Exodus: An Introduction and Commentary*, Tyndale Old Testament Commentaries (Leicester, UK: Inter-Varsity, 1973), 210.

4 John I. Durham, *Exodus*, Word Biblical Commentary (Waco, TX: Word, 1987), 410.

5 Gene Edward Veith, "Stealing Beauty," *World* (March 20, 2004): 37.

6 Ibid.

7 Dorothy L. Sayers, *The Mind of the Maker* (1941; repr. Cleveland: World, 1956), 34.

8 Abraham Kuyper, *Calvinism: Six Stone Foundation Lectures* (Grand Rapids: Eerdmans, 1943), 142.

All Kinds of Art

1 John I. Durham, *Exodus*, Word Biblical Commentary (Waco, TX: Word, 1987), 410.

2 Leland Ryken, *The Liberated Imagination: Thinking Christianly about the Arts*, The Wheaton Literary Series (Wheaton, IL: Harold Shaw, 1989), 54–57.

3 John Calvin, quoted in Abraham Kuyper, *Calvinism:*

Six Stone Foundation Lectures (Grand Rapids: Eerdmans, 1943), 153.

The Good, the True, and the Beautiful

1 Annie Dillard, *Holy the Firm* (New York: Harper & Row, 1984), 72.

2 H. R. Rookmaaker, *Modern Art and the Death of a Culture* (Wheaton, IL: Crossway, 1994), 38.

3 Francis A. Schaeffer, *Art and the Bible* (Downers Grove, IL: InterVarsity, 1973), 56–59.

Art for the Glory of God

1 Ralph Waldo Emerson, "The Rhodora," quoted in Leland Ryken, *The Liberated Imagination: Thinking Christianly about the Arts*, The Wheaton Literary Series (Wheaton, IL: Harold Shaw, 1989), 85.

2 Henri Matisse, quoted in George Steiner, *Real Presences* (Chicago: University of Chicago, 1991), 209.

3 Igor Stravinsky, quoted in Vera Stravinsky and Robert Craft, "Stravinsky's Early Years," *Ovation* 1 (May 1980): 20.

4 Nigel Goodwin, as quoted by Makoto Fujimura, "That Final Dance," in Ned Bustard, ed., *It Was Good—Making Art to the Glory of God* (Baltimore: Square Halo Books, 2000), 58.

5 Francis A. Schaeffer, *Art and the Bible* (Downers Grove, IL: InterVarsity, 1973), 96.

Beautiful Savior

1 Jonathan Edwards, *The Nature of True Virtue*, quoted in

Leland Ryken, *The Liberated Imagination*, The Wheaton Literary Series (Wheaton, IL: Harold Shaw, 1989), 70.

2 Francis A. Schaeffer, *Art and the Bible* (Downers Grove, IL: InterVarsity, 1973), 30.

3 Ibid., 31.

Philip Graham Ryken is president of Wheaton College. He is Bible teacher for the Alliance of Confessing Evangelicals, speaking nationally on the radio program *Every Last Word*. Dr. Ryken was educated at Wheaton College, Westminster Theological Seminary, and the University of Oxford, where he received his doctorate in historical theology. He and his wife, Lisa, have five children.